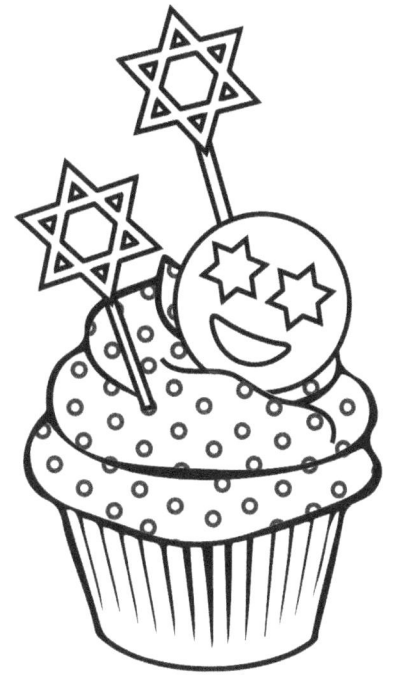

O.M.G. HANUKKAH

| 24 REALLY FUN HANUKKAH COLORING PAGES |

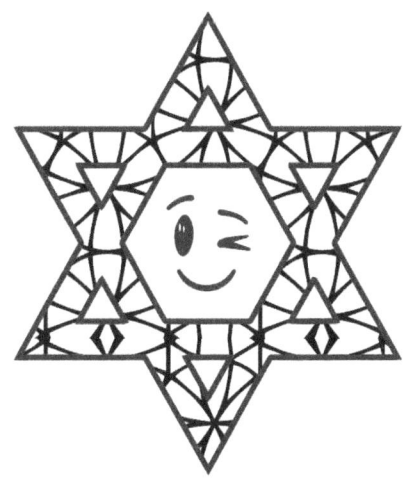

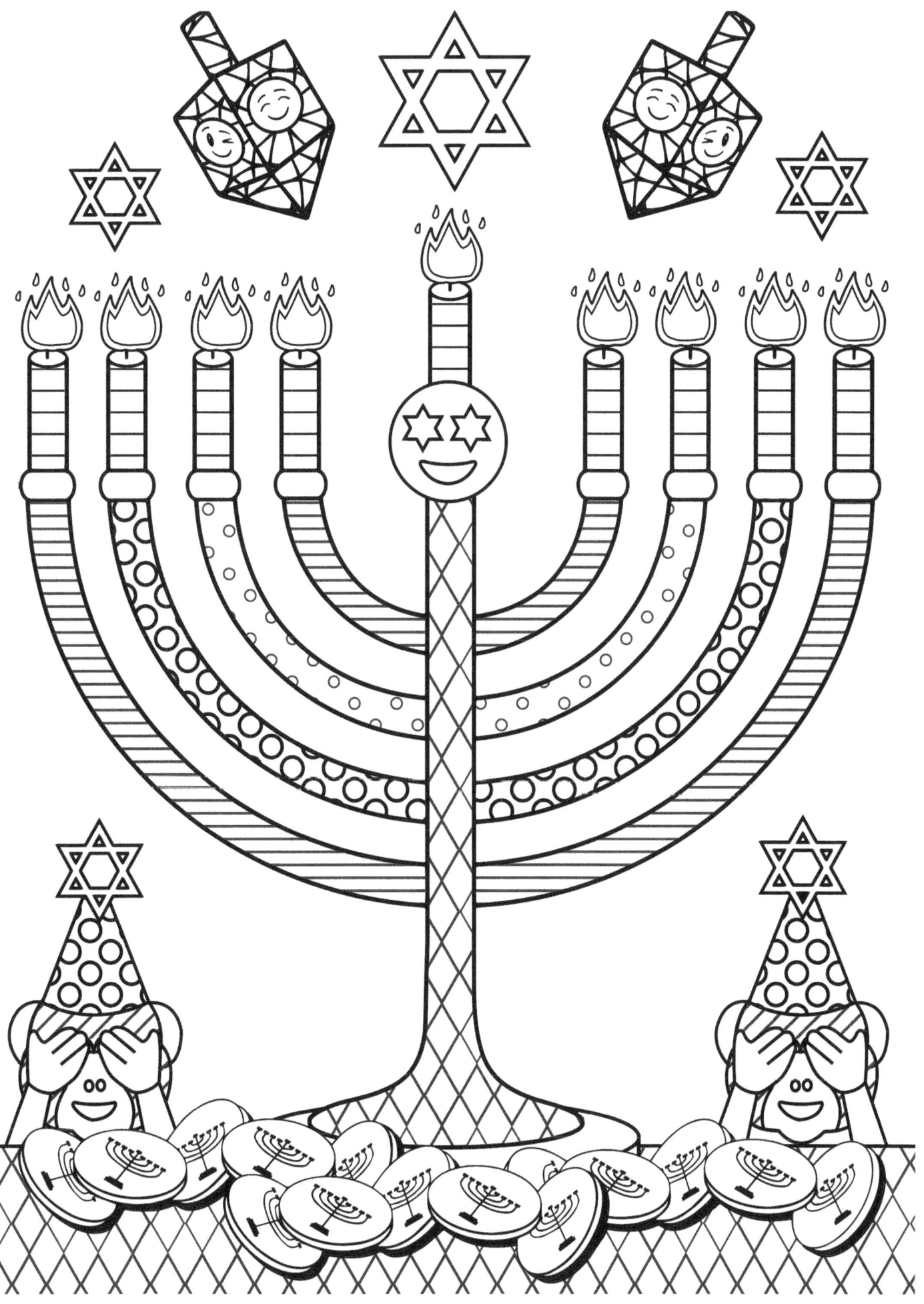

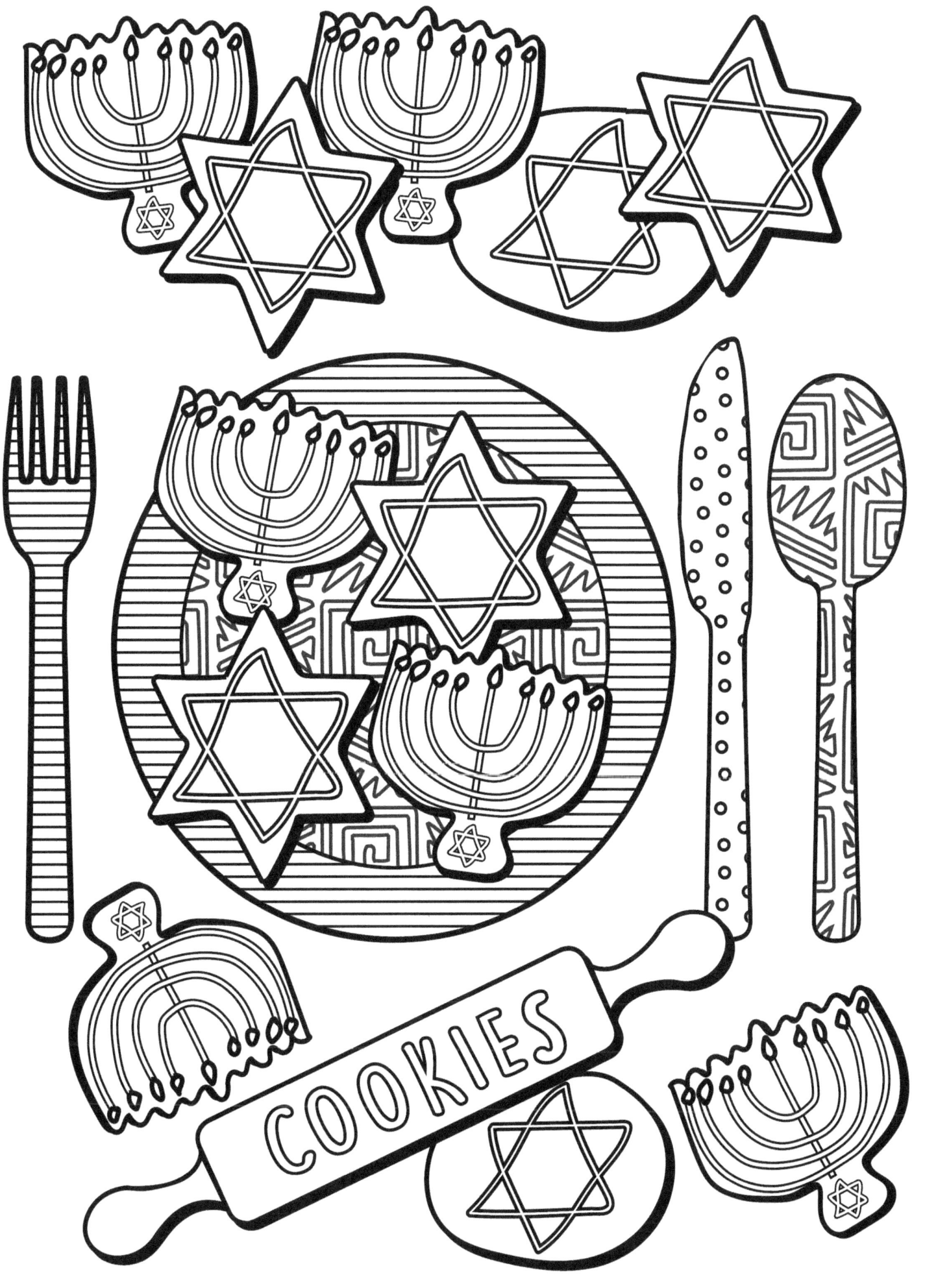

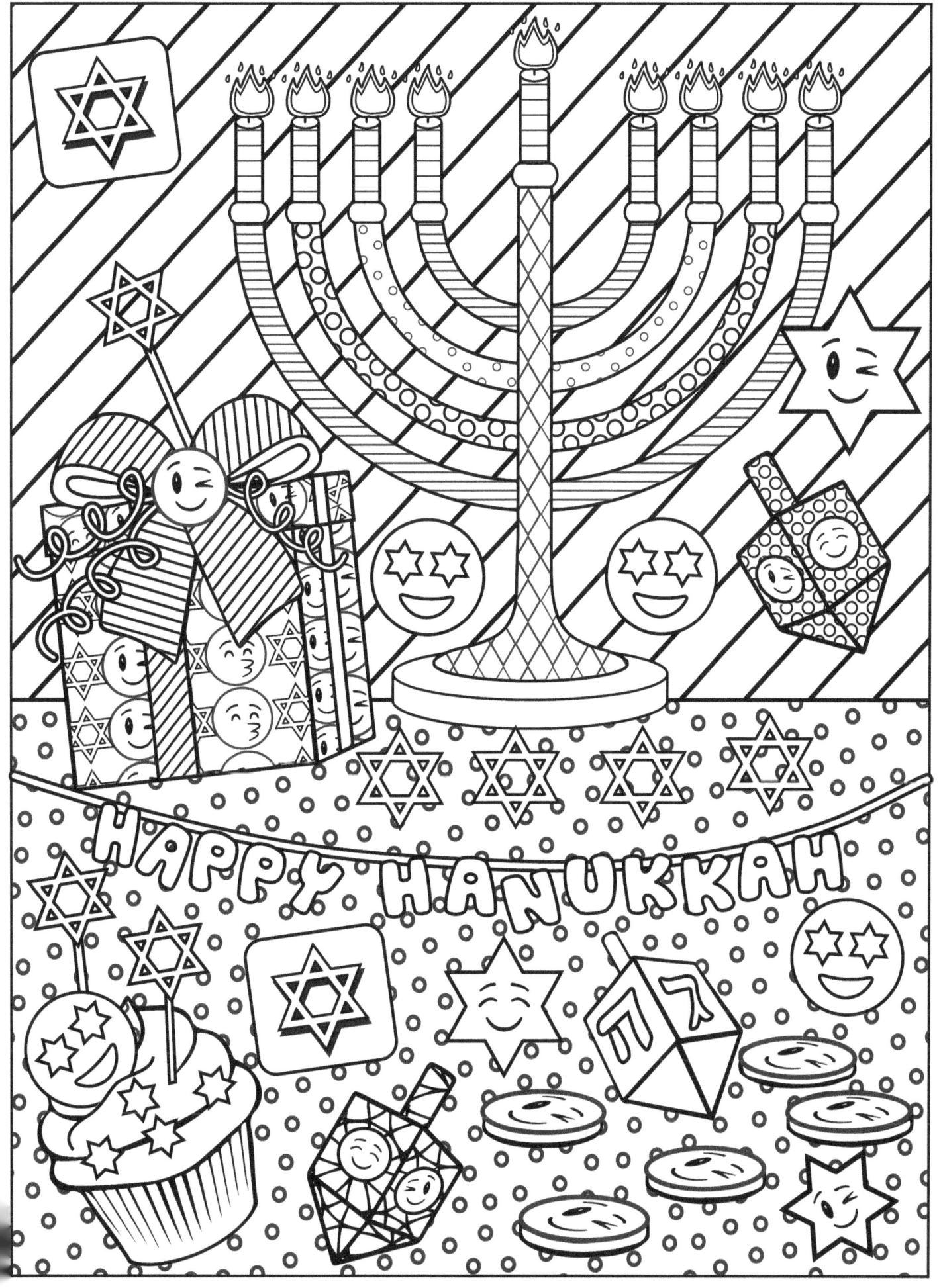

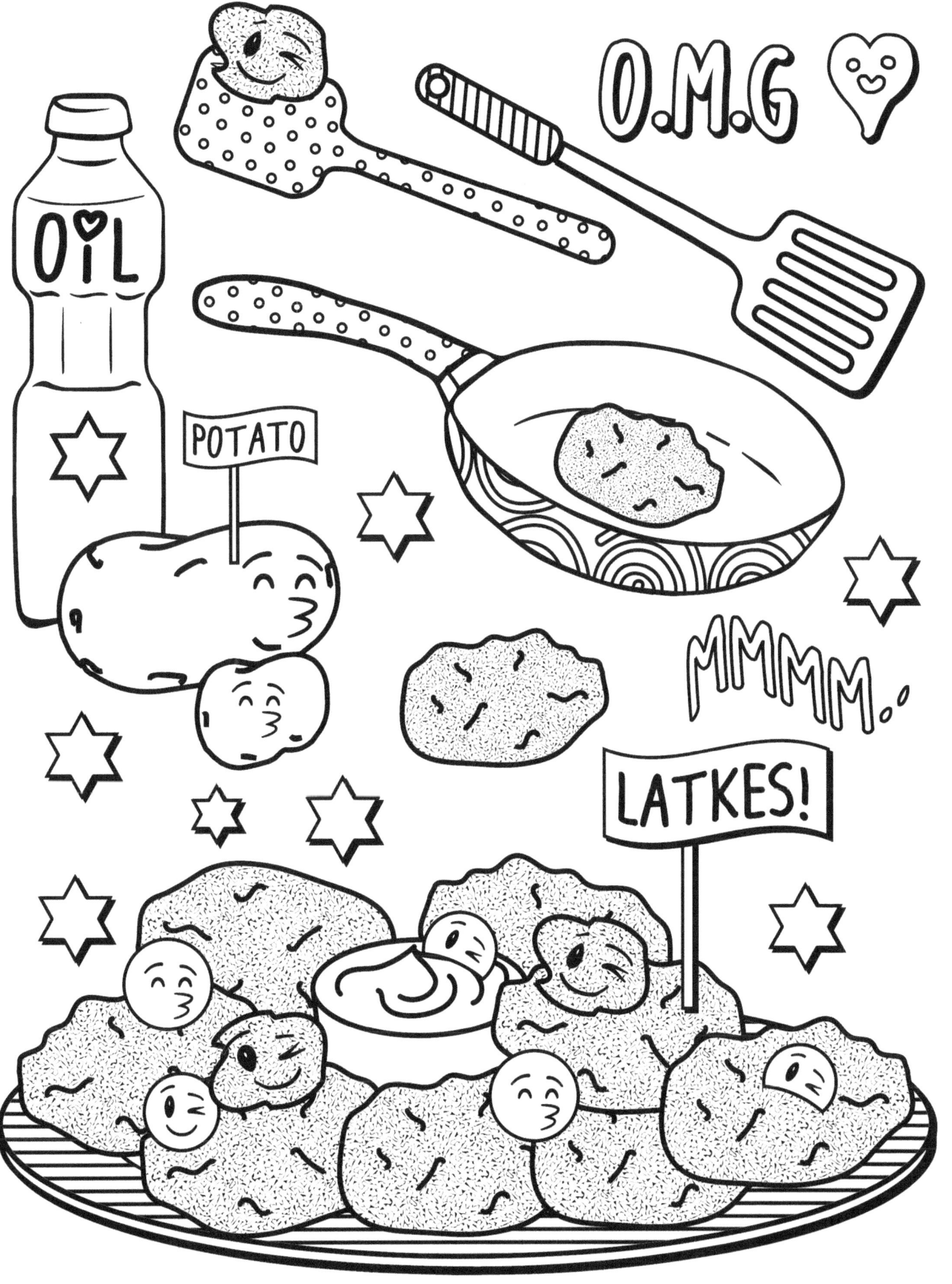

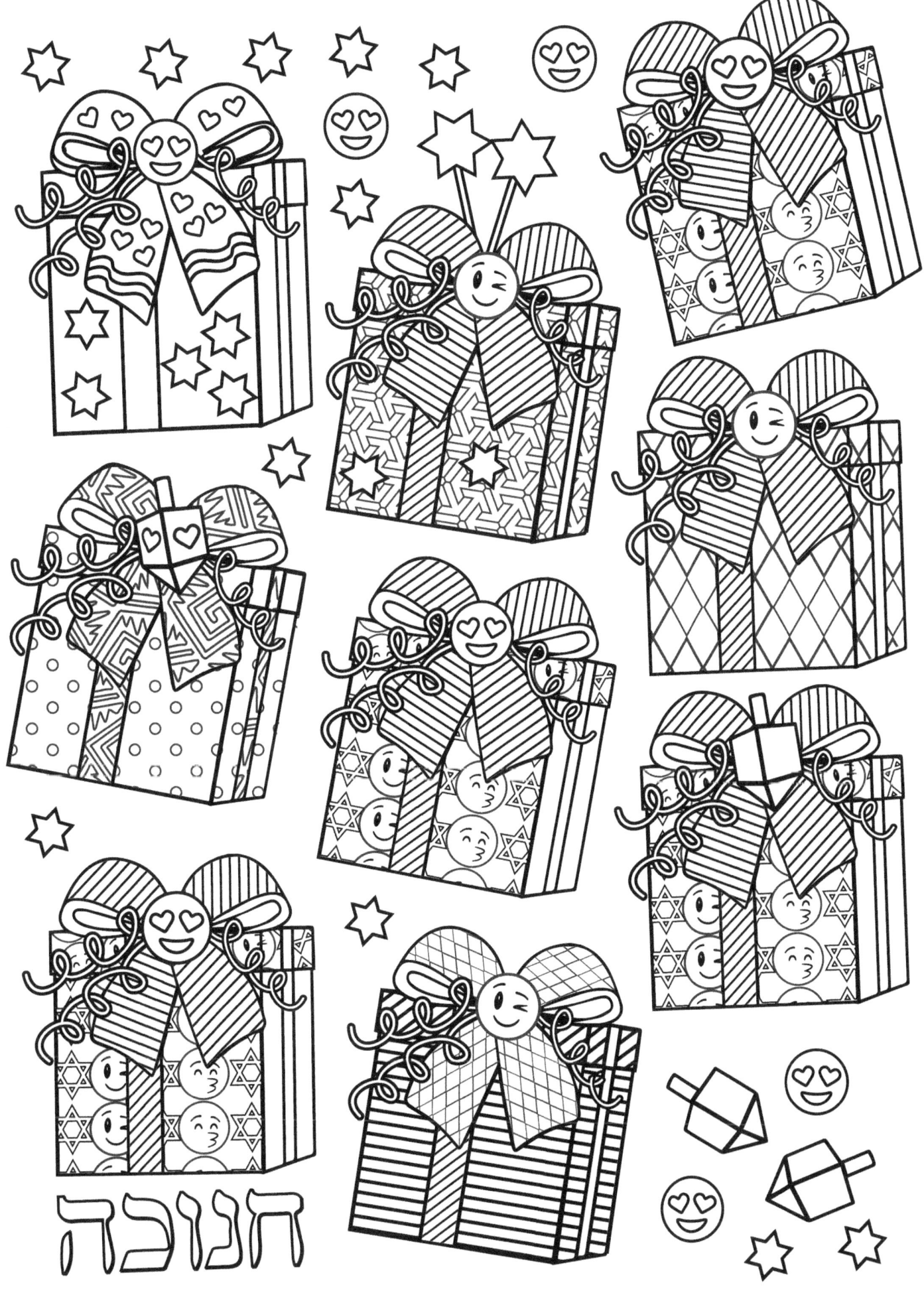

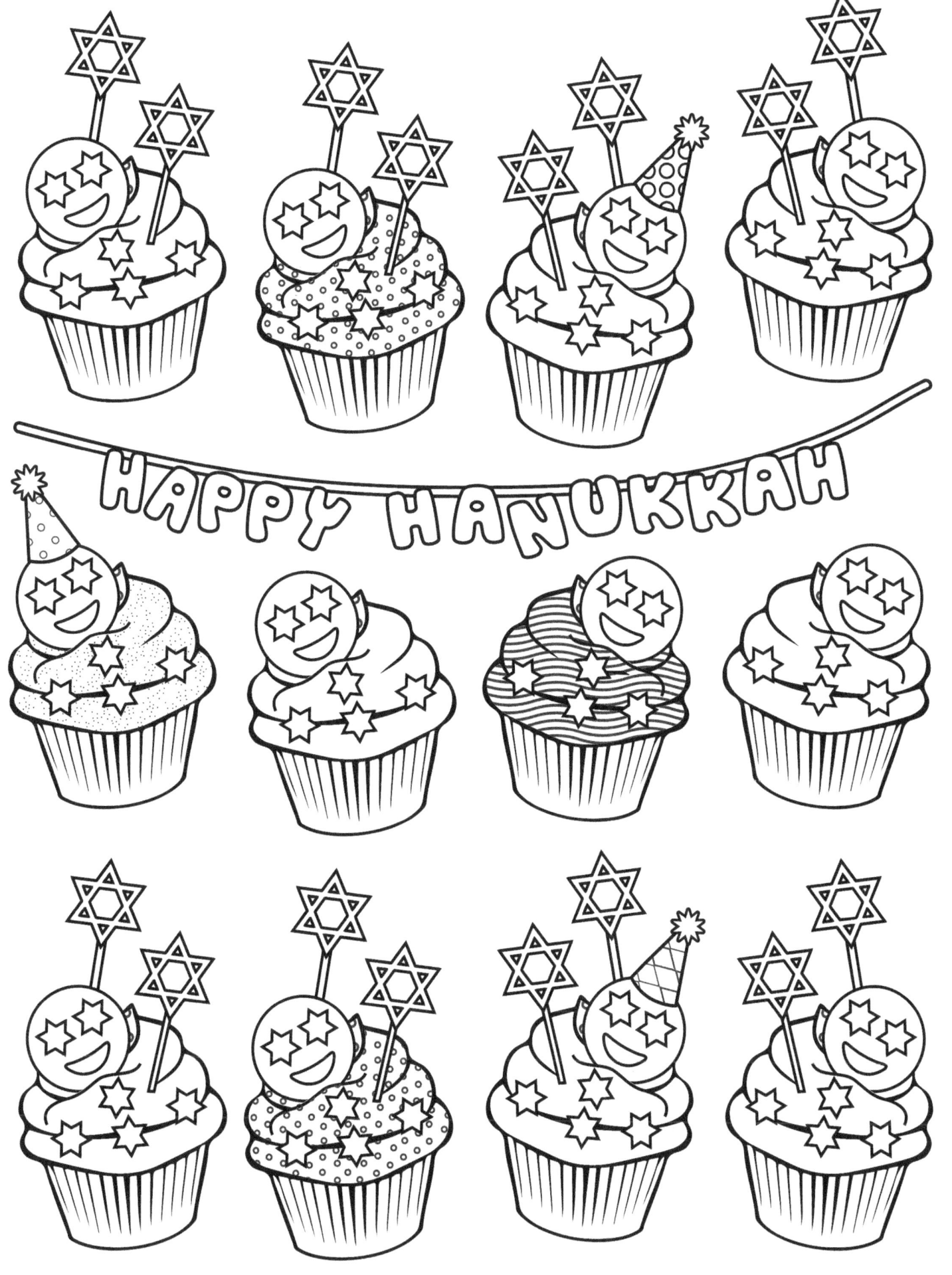

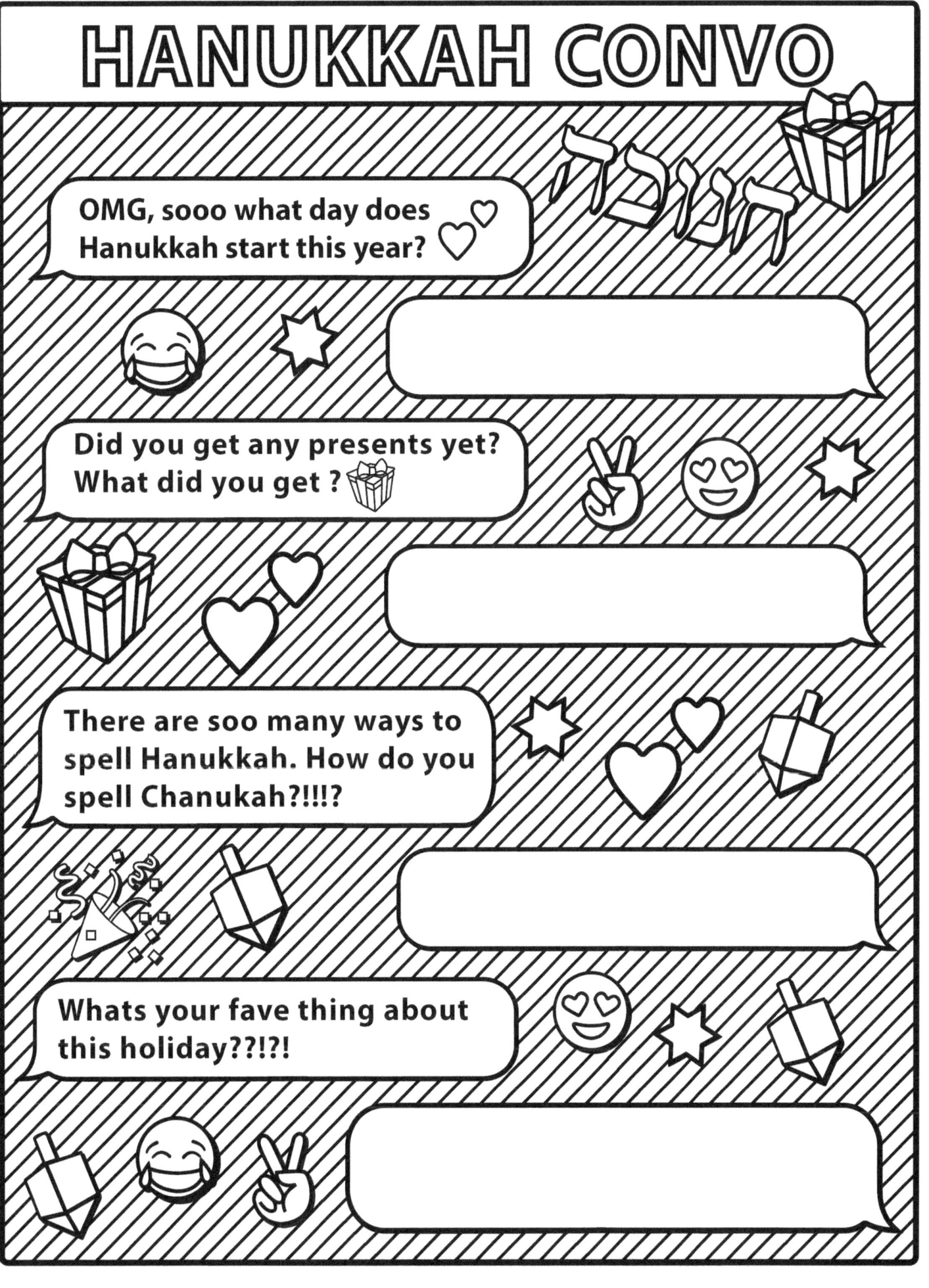

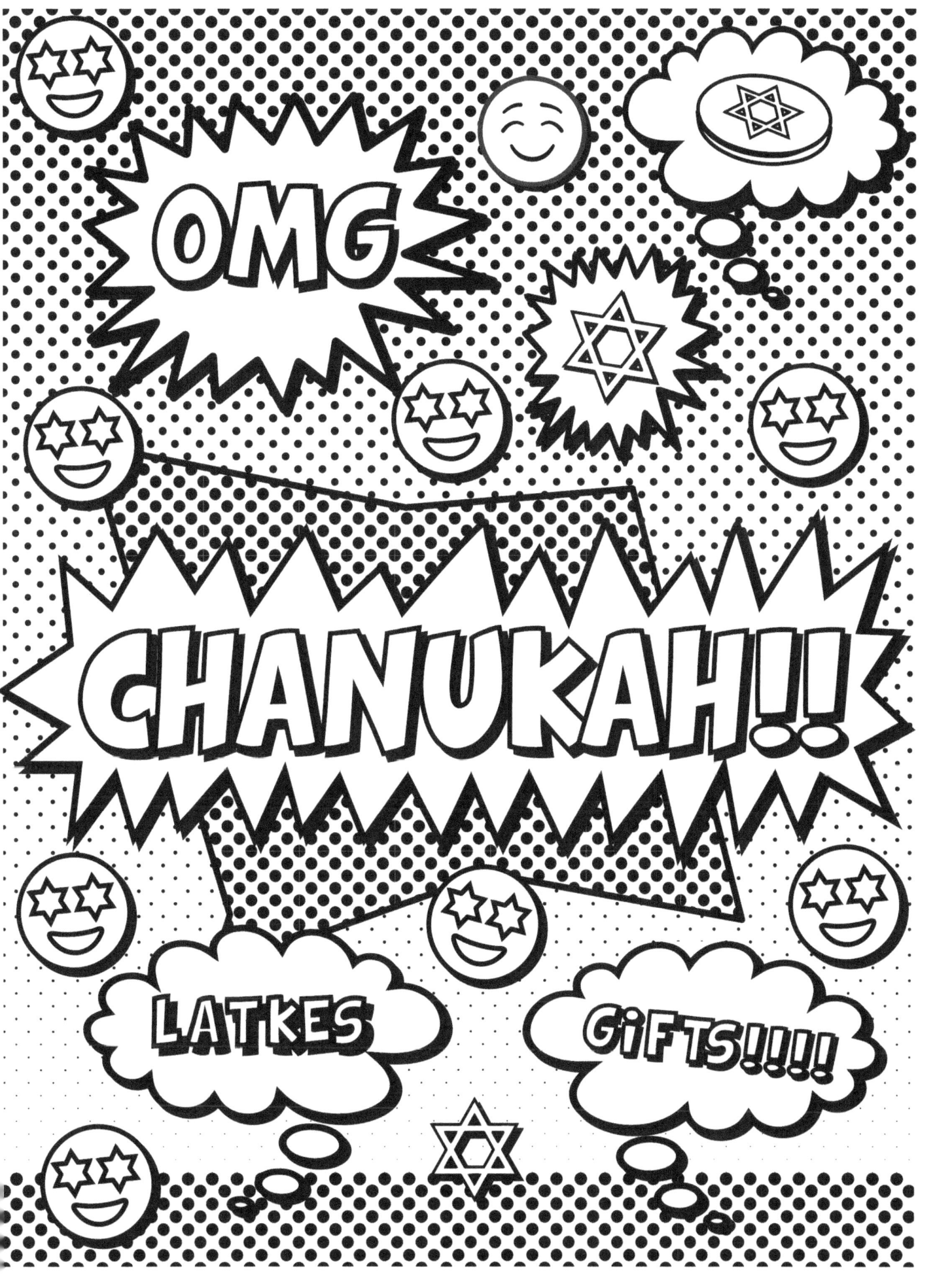

HANUKKAH
8 NIGHTS
LIGHT THE MENORAH
GIFTS
CHOCOLATE GELT
POTATO LATKES

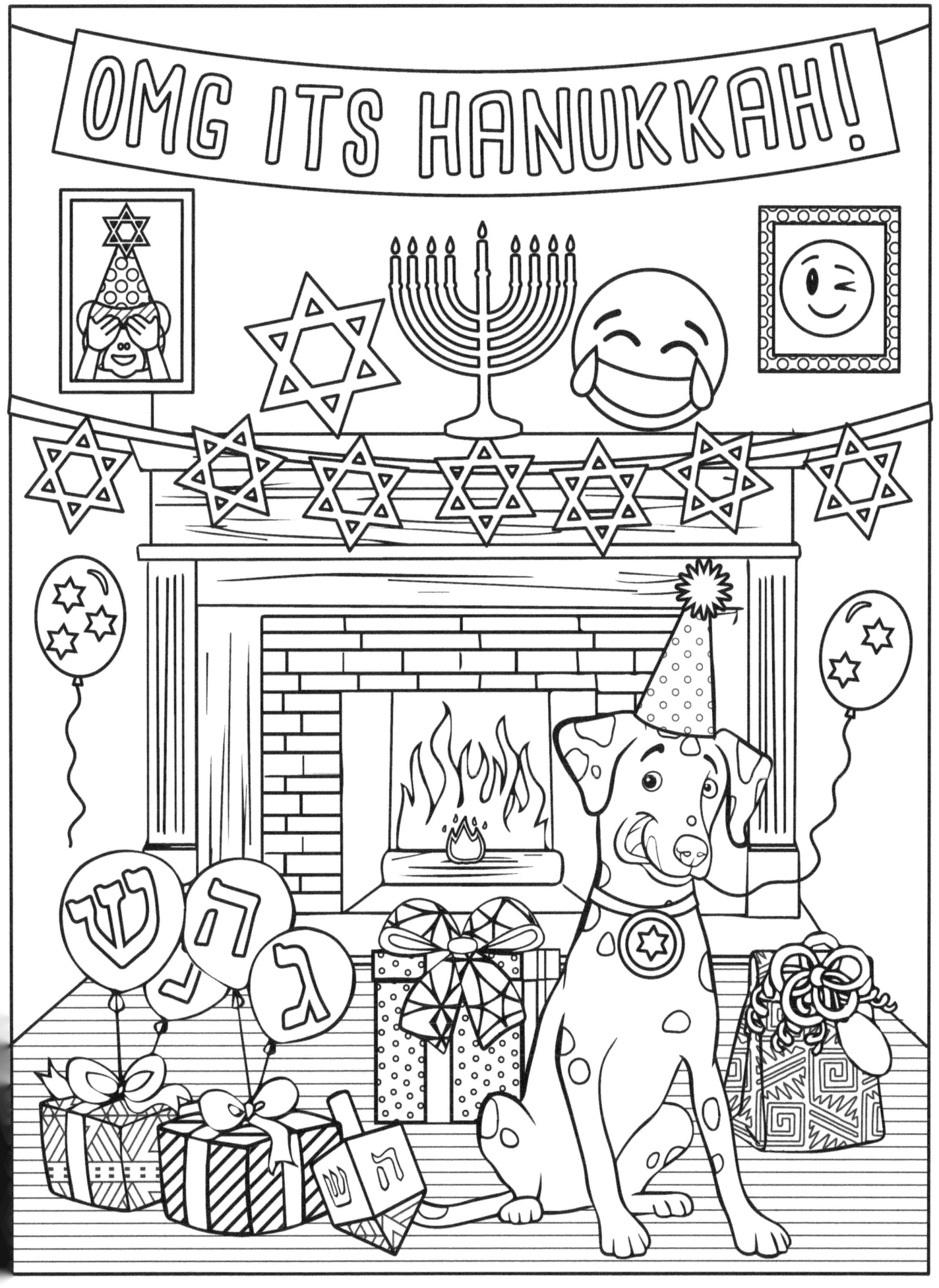

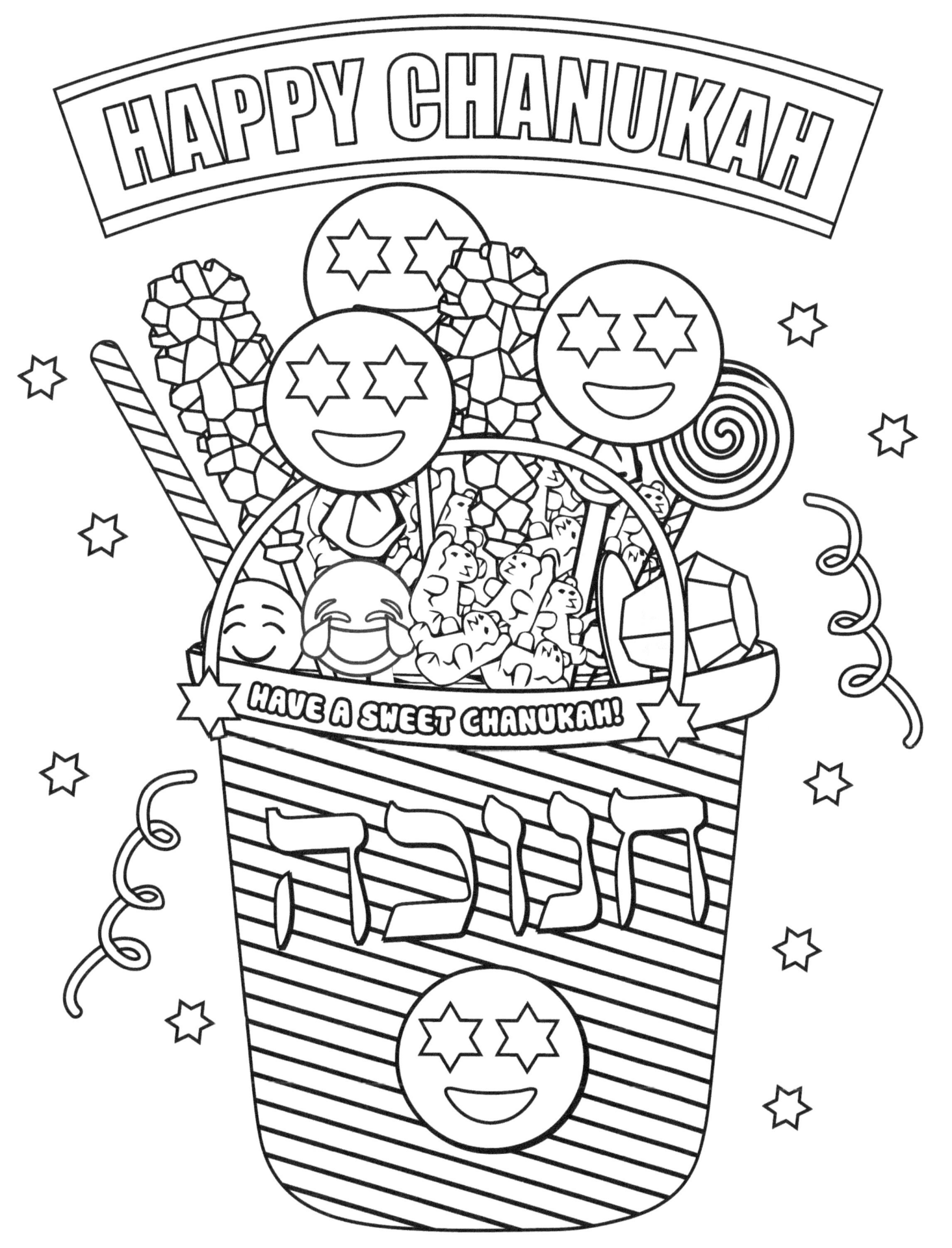

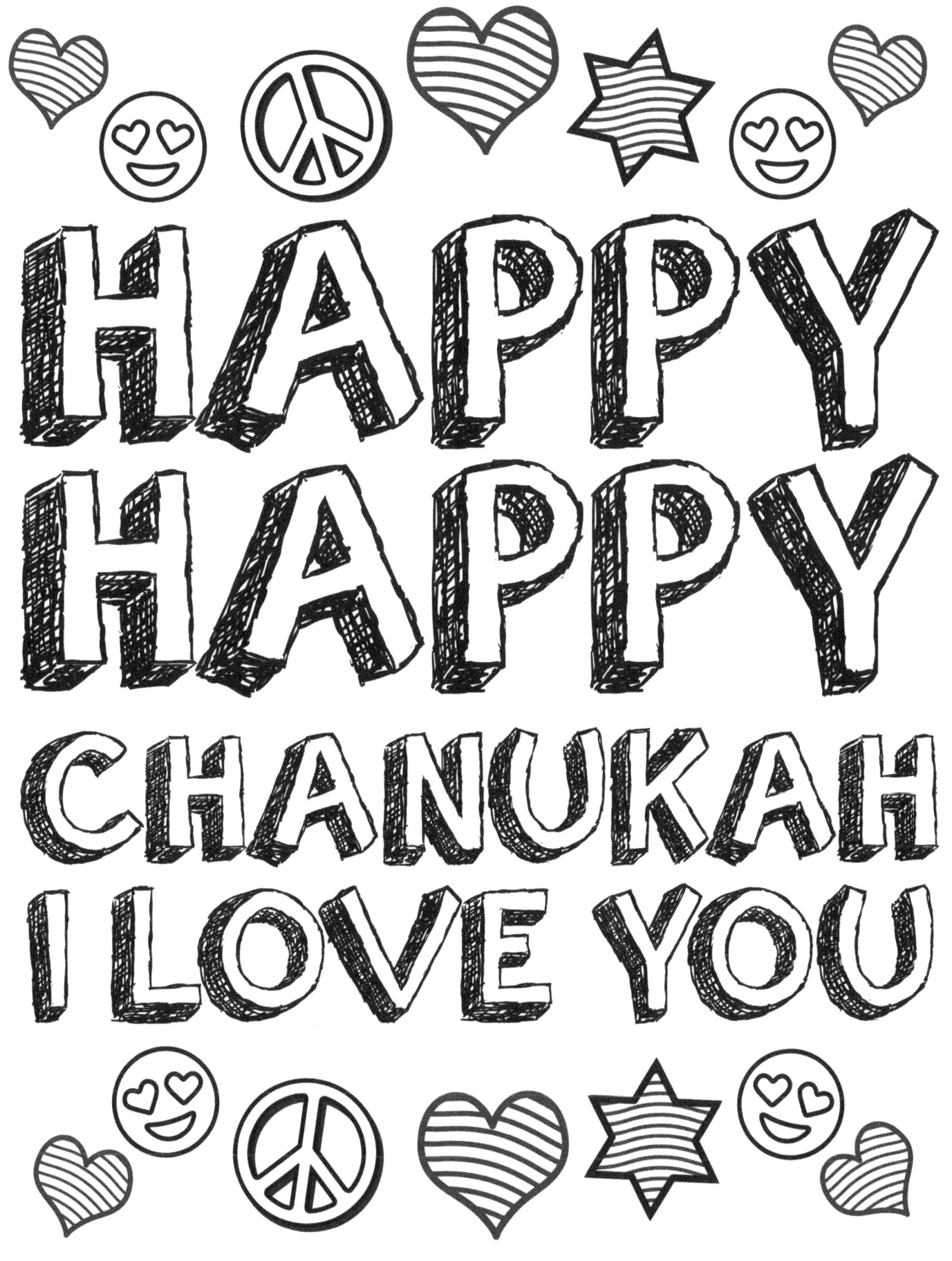

cut with scissors (and give to someone you love)

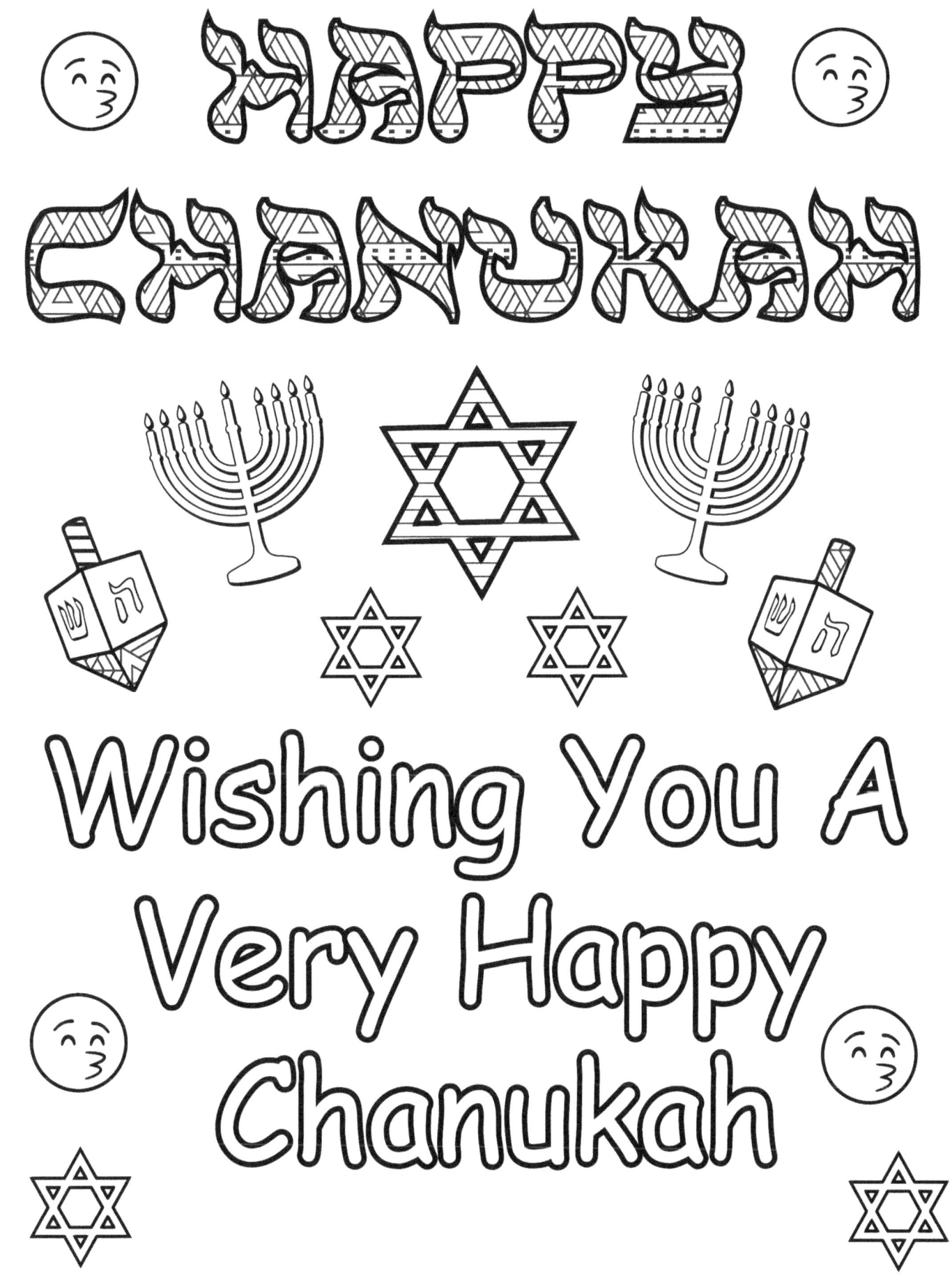

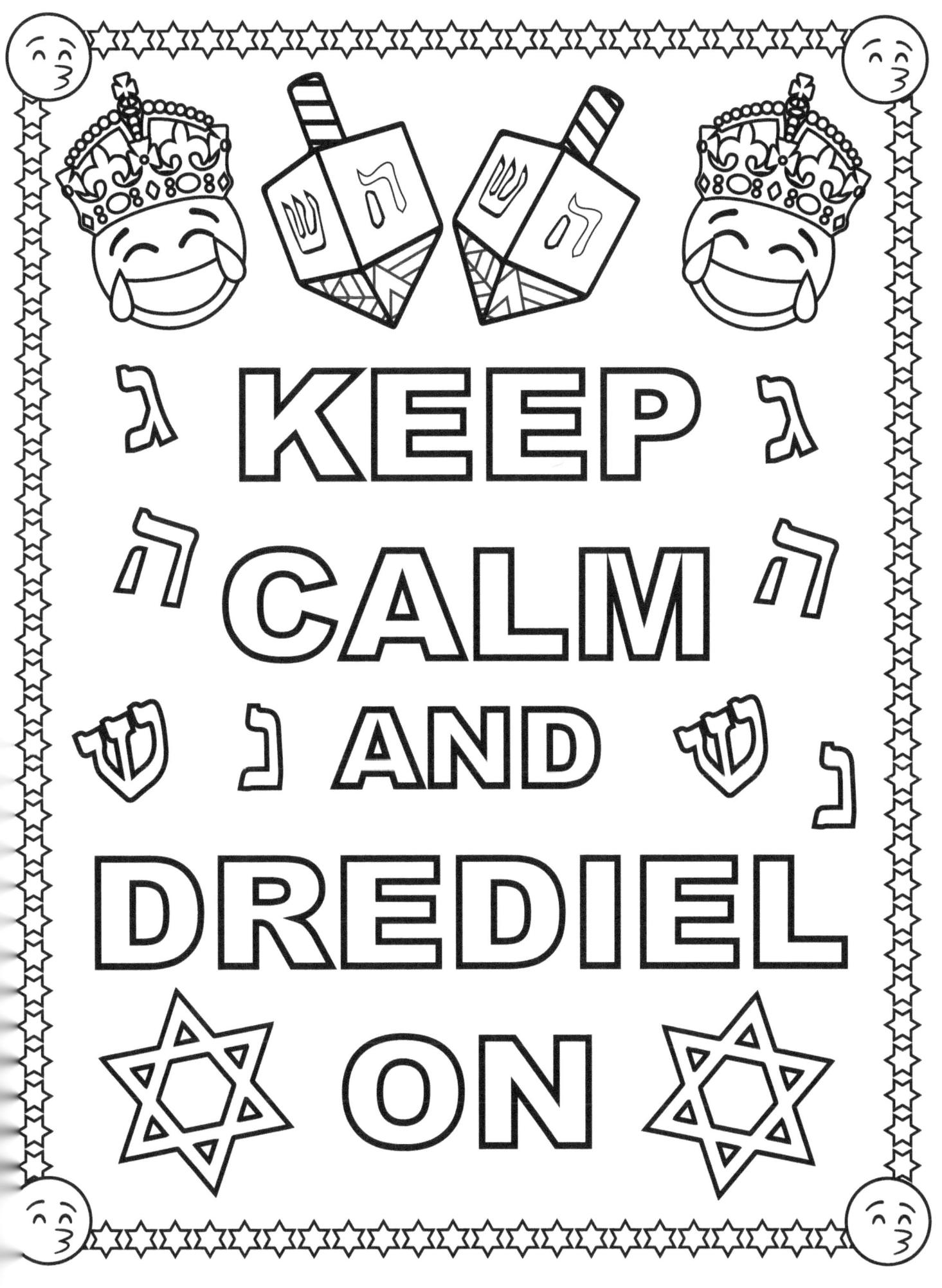

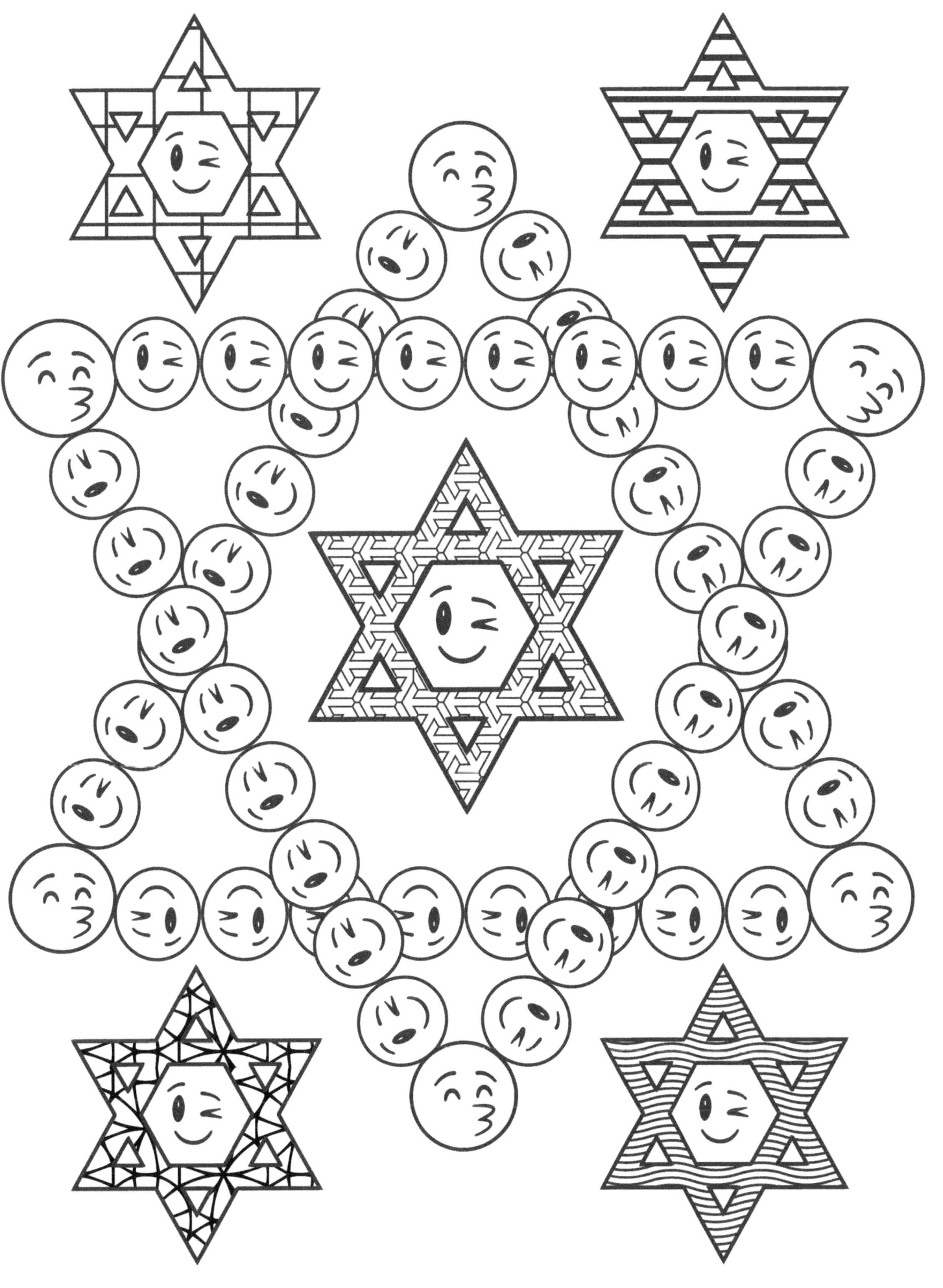

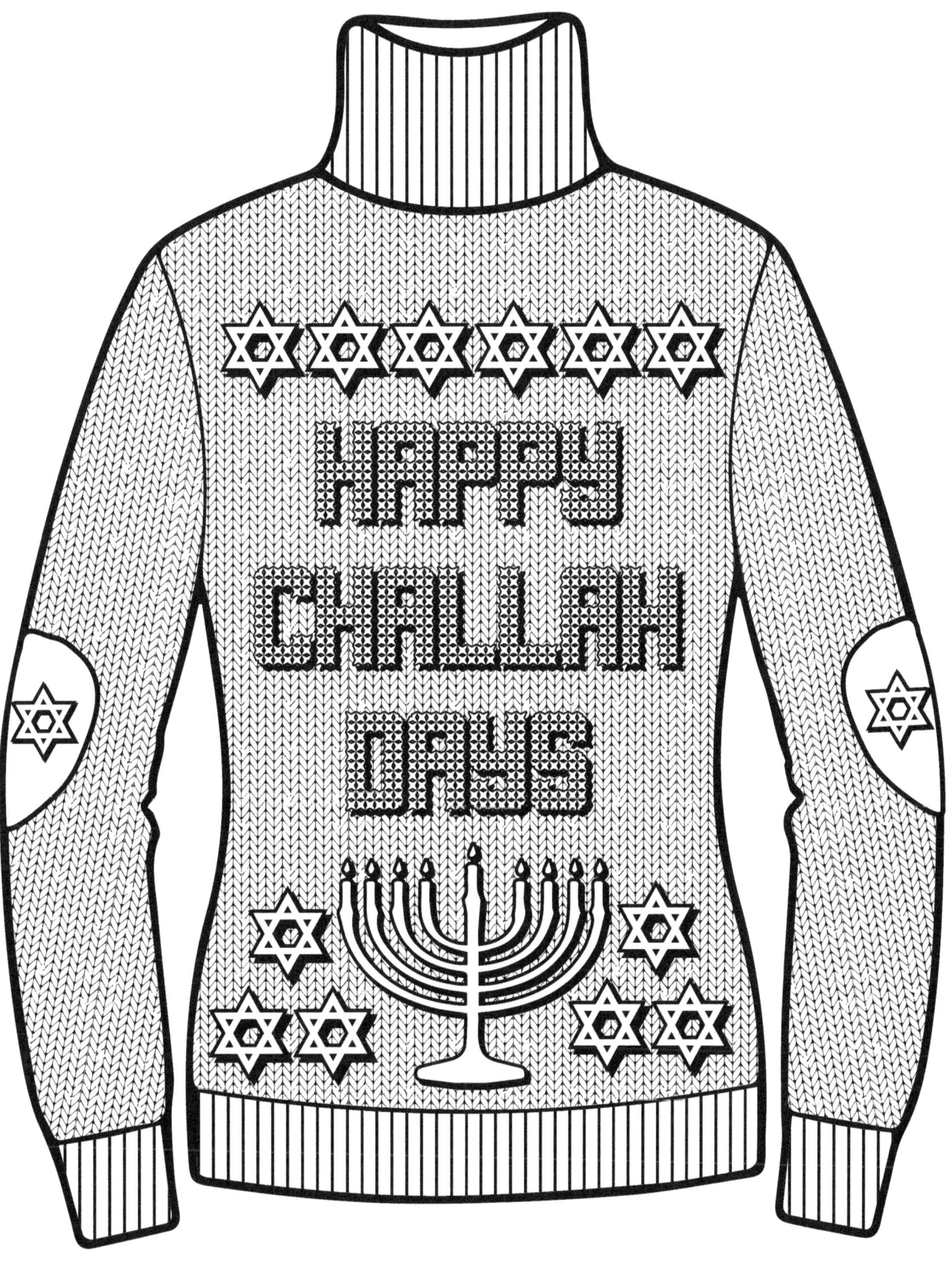

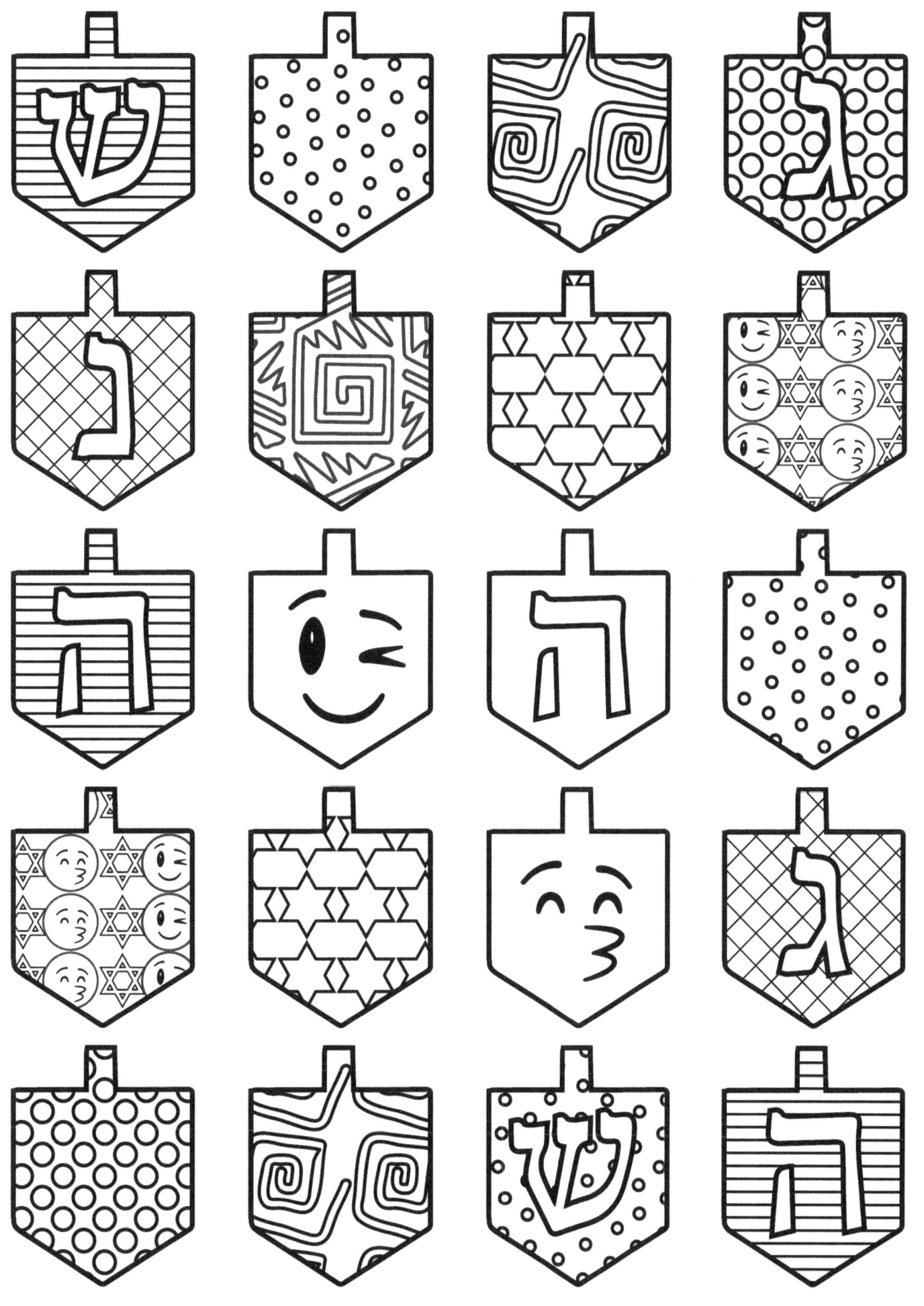

www.ingramcontent.com/pod-product-compliance
Lightning Source LLC
Chambersburg PA
CBHW080604190526
45169CB00007B/2876